CITYSKETCH
LONDON

A DOODLE BOOK FOR DREAMERS

CITYSKETCH
LONDON

NEARLY 100 CREATIVE PROMPTS FOR SKETCHING THE CITY ON THE THAMES

Illustrations by Melissa Wood

Text by Monica Meehan, Joanne Shurvell, and Melissa Wood

Race Point
PUBLISHING

I dedicate this book to:

NWI + HBI + CWI

My gifted map readers, my kooky road trippers,
my charming travel mates,
you've made our road, gladly traveled
a wondrous life.

Race Point Publishing
An imprint of Quarto Publishing Group USA Inc.
276 Fifth Avenue, Suite 205
New York, New York 10001

RACE POINT PUBLISHING and the distinctive Race Point Publishing
logo are trademarks of Quarto Publishing Group USA Inc.

ISBN: 978-1-937994-55-6

Library of Congress Cataloging-in-Publication Data is available

Illustrations: Melissa Wood
Text: Monica Meehan, Joanne Shurvell, and Melissa Wood
Editorial Director: Jeannine Dillon
Project Manager: Erin Canning
Designer: Jacqui Caulton

Printed in China

1 3 5 7 9 10 8 6 4 2

CONTENTS

HOW TO USE THIS BOOK

Big cities are full of promise. From the amazing art and architecture to the diverse food and culture, each city has its own unique collection of treasures to unearth. *CitySketch* is the perfect way to sketch the delights of your favorite urban retreat. Each page contains a fascinating anecdote as well as a creative prompt about a unique and lovable part of the city. On the opposite side of the page, a sketch is started for you. Then it's up to you to unleash your imagination to complete the sketch and add your own signature style to it. You can use *CitySketch* to practice sketching and doodling, to enhance your creativity, or simply to capture your favorite city on paper. So get out your pencil and start dreaming!

ARCHITECTURE

THE WHITE TOWER

Beefeaters may be most recognizable from the gin bottle label, but in real life they're the dutiful guards of one of England's earliest, and most iconic, castles: the White Tower. This once whitewashed stronghold sits at the center of the bulky, famous fortress known as the Tower of London, which was commissioned in the 11th century by William the Conqueror.

✎ Draw the White Tower from the corner where Anne Boleyn stood moments before her life ended.

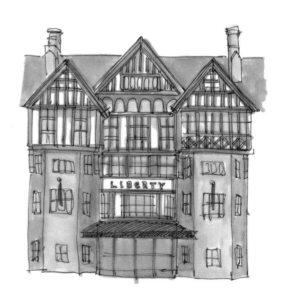

LIBERTY OF LONDON

Built in 1924 from the timbers of the ships HMS *Impregnable* and HMS *Hindustan*, the iconic luxury goods store Liberty of London was designed in the Tudor Revival style, which had been raging throughout England at the time. This bespoke British company is named after founder Arthur Lasenby Liberty, a former tea merchant, and is now a global brand.

✎ Draw the sunlit wells and open floors of Liberty of London's famous interior.

WESTMINSTER ABBEY

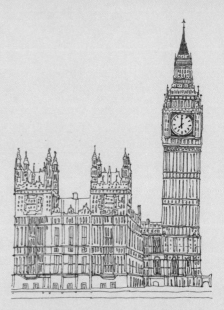

Adjacent to the widely recognized Houses of Parliament is the famed Westminster Abbey, the site of all but two English coronations and the final resting place of Charles Dickens, Rudyard Kipling, Charles Darwin, and Queen Elizabeth I, as well as 3,300 others. Over the centuries since it was first founded in the year 960, the Abbey has undergone numerous renovations and additions, and it continues to attract visitors with its opulent medieval style.

✎ Sketch the historic entryway of the Abbey, the iconic location of Princess Diana's funeral in 1997.

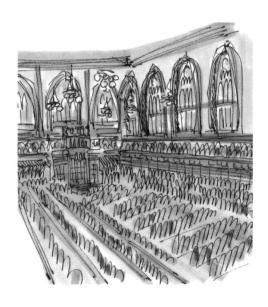

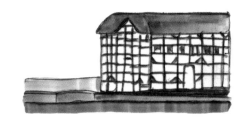

SHAKESPEARE'S GLOBE THEATRE

Originally built in 1599, lost to fire in 1614, rebuilt, and then demolished in 1644, the famed Globe Theatre was gloriously brought back to life, yet again, roughly 350 years later—and just a few hundred yards from where it originally stood. Happily, the same Shakespeare works that were performed on the banks of the Thames during the Bard's lifetime can live on in this iconic performance space for generations to come.

✎ Top gallery, front row. Sketch the view below as you watch a production of *Much Ado About Nothing*.

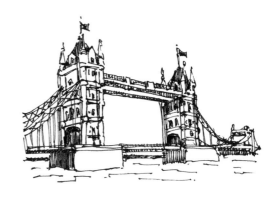

TOWER BRIDGE

Begun during the end of Queen Victoria's reign and frequently mistaken for London Bridge, Tower Bridge was constructed with steam-powered bascules in order to raise and lower the bridge for tall ships sailing along the Thames. Painted a jolly red, white, and blue to commemorate Queen Elizabeth's Silver Jubilee in 1977, the bridge is near the Tower of London and boasts breathtaking views from its glass-enclosed pedestrian walkway.

✐ Envision sailing up to the bridge and make a quick sketch of the neo-Gothic towers above.

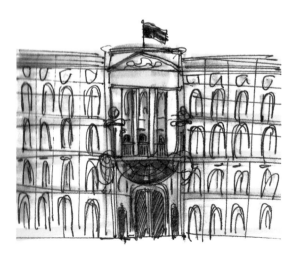

BUCKINGHAM PALACE

Neoclassical in style and international in reputation, Buckingham Palace has been the London residence of the British royal family since the coronation of Queen Victoria in 1837. Built as a private house for the Duke of Buckingham in 1703 and re-imagined as a royal residence by architect Sir John Nash in the 19th century, the palace also serves as the working headquarters for the monarchy, as well as host to various ceremonies, banquets and State Visits.

Most famous—at least to this current generation of global fans— is the balcony perched just above the entrance. As tourists parade along the majestic iron gates, vying to snap a photo of the unblinking Queen's Guards, all eyes turn to see, in person, the perch made famous as the impromptu stage for the royal family in moments of national importance.

🖉 Imagine standing on the famous balcony and draw the view shared by the royals as they greet the adoring crowds below.

VICTORIA STATION

With more than 115 million travelers passing through it each year, London's Victoria Station was born of several interconnected and independent train stations. From the mid-1800s through the late 20th century, the station underwent myriad additions, enhancements, and construction projects to keep pace with increasing rail, Tube, and air travel. Today, the striking iron and glass edifice is able to handle a vast amount of daily business.

✎ Travel back in time by sketching the Venice Simplon-Orient-Express train as it steams into Victoria Station.

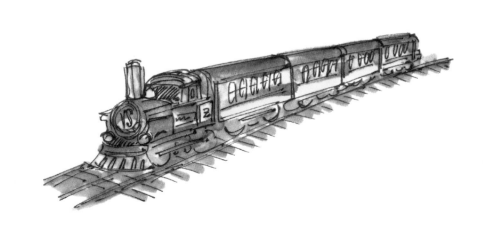

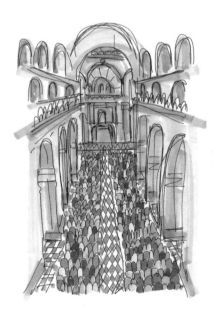

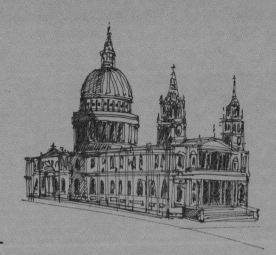

ST. PAUL'S CATHEDRAL

Baroque, massive, and pointedly dominating the London skyline, St. Paul's Cathedral was built in the late 1600s to replace its much smaller predecessor, which had been irreparably damaged in the Great Fire of London. During construction, the entire building was covered in scaffolding in order to keep its appearance a mystery until completion. Designed by famous architect Sir Christopher Wren after the Great Fire, the building was completed in 35 years. Wren himself is buried in the crypt of St. Paul's; his tablet is inscribed "Reader, if a monument you seek, look around you."

✎ Sketch the breathtaking cathedral and its massive dome from the view across the Thames at sunset.

MILLENNIUM BRIDGE

Scheduled to open at the dawn of the new millennium, the (officially named) London Millennium Footbridge was the first to be built in London in over a century. And though it did originally open in 2000, it was quickly closed for repair due to pedestrian complaints of "wobbliness"; it reopened to the public in 2002. Linking St. Paul's Cathedral to the Tate Modern across the bustling Thames, this pedestrian bridge made cinematic history as the one destroyed by the maniacal Death Eaters in *Harry Potter and the Half-Blood Prince.*

✎ Sketch pedestrians as they make their way across Millennium Bridge. Add a boat sailing beneath it with its passengers marveling at St. Paul's Cathedral.

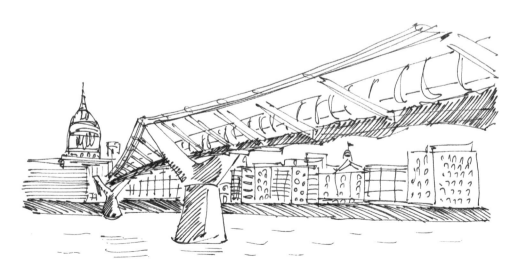

BT TOWER

From technological advances come ... design
innovations? Built from a concrete pillar from
which all of the floors are suspended, the BT Tower was initially
devised as a TV tower. "Mod" in its look, it was built during the
mid-1960s: the age of Twiggy and The Beatles. Sending over a
million signals a year, the form-follows-function structure has
become a permanent fixture in the diverse landscape of London
architecture.

✐ Add the cluster of satellites to this sketch of the BT Tower. Include
a few pedestrians on the street in colorful 1960s "mod" fashion.

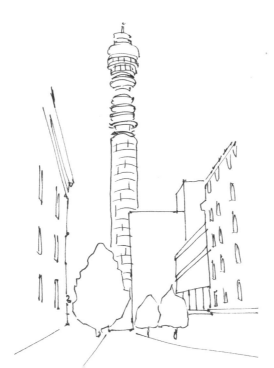

KENSINGTON PALACE

Once a favorite London residence of the British sovereign, Kensington Palace was built during the reign of William III and Mary II. It was originally a Jacobean structure known as Nottingham House, and architect Sir Christopher Wren was given the job of renovating and adding to it. The royals took up residence in the amplified quarters in 1689, calling it Kensington House. Its current function is as official royal apartments for esteemed members of the royal family, including the direct heirs to the British throne. Witness to centuries of royal life, it is best remembered as the former home of Diana, Princess of Wales.

✎ During the days following Princess Diana's death, it was estimated that over a million bouquets were left at the elaborate gold gates of Kensington Palace. Sketch the iconic gates with some of the touching bouquets left at their base in Princess Diana's memory.

KENSINGTON PALACE

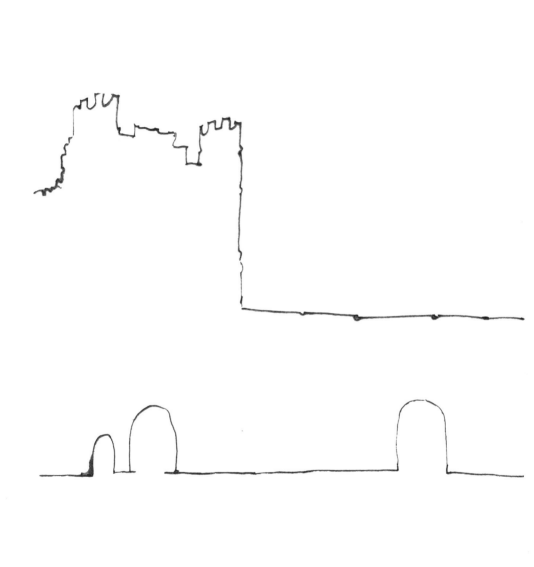

ST. JAMES'S PALACE

The Tudor edifice was built by one of England's most infamous kings, Henry VIII, and much of the original building still stands today. Planned initially as a home to share with his wife, Anne Boleyn, her enjoyment of the beautiful palace was limited to just one brief overnight stay. With orders given to remove Anne's royal crest after her untimely death, lovers' knots with the entwined initials "HA" still exist in a few fireplaces in the private apartments, despite Henry's efforts to rewrite history.

Honoring its true origins, the palace has been witness to centuries of English royal history and scandal. Over time, four courts were added to the original palace to form an expanse of royal residences.

✎ Draw the great Tudor gatehouse at the southern face, including King Henry VIII's royal cypher.

ST. PANCRAS

These days travelers passing through the stately St. Pancras
train station wield passports to hop aboard the Eurostar
for quick passage to the Continent. Or perhaps to check out
the station that housed the imaginary Platform 9¾ and the
Hogwarts Express in the *Harry Potter* movies. St. Pancras,
however, once stood watch over a very different version of train
travel when it first opened its grandiose doors in 1868. The
result of a design contest commissioned by the Midland Railway
Company, St. Pancras boasted an opulent hotel and what was,
at the time, the largest unsupported roof in the world. The new
roof today has 18,000 panes of self-cleaning glass.

✎ Sketch St. Pancras in its heyday, complete with an 1880s
hansom cab parked out front.

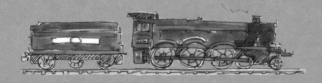

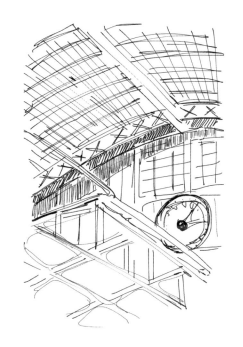

30 ST. MARY AXE

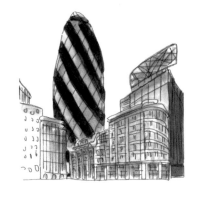

Dubbed "The Gherkin" due to its curious "pickle" shape, 30 St. Mary Axe boasts the (physically) highest eating establishments in London. It is three times the height of Niagara Falls and was specifically designed to allow for the most natural light possible in the building (reducing both artificial light and energy). Patterned in a glaze of diamond-shaped glass, the building reflects images of London in a beautiful kaleidoscopic fashion.

✎ Sketch this fantastically odd-shaped building amid its smaller neighbors in the City of London.

HARRODS

From its humble beginnings as a tea merchant to its
role in bringing Britain's first escalator to London,
Harrods is an English institution. The current store,
with its signature green shopping bags and palatial
elegance, was built at the end of the 19th century
by architect Charles Williams Stephens. It houses an
astonishing million square feet (90,000 sq m) or so of retail
space, making it one of the world's largest department stores.

✏ Sketch the exterior of the luxurious Harrods as you approach
from Hyde Park Corner. Be sure to try and capture the iconic
terracotta façade and Baroque dome.

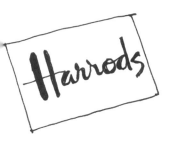

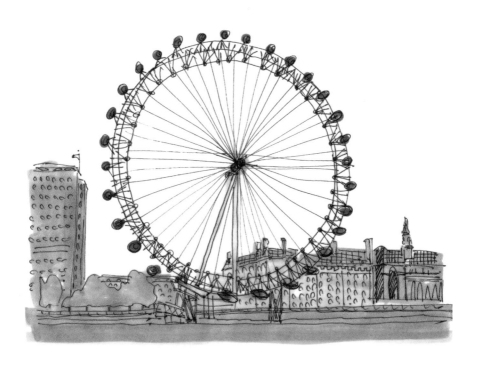

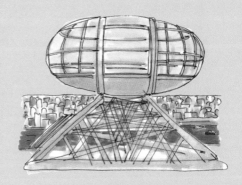

THE LONDON EYE

Built along the edge of the River Thames and engineered with
a single-sided support to assure unblocked views of London's
grand vistas, the London Eye has become the UK's most popular
paid tourist attraction (over 3.5 million customers per year, to
be more precise). Assembled horizontally and then mechanically
tilted up to its upright position, the Eye—featuring 32 glass
capsules—opened to the public in 2000.

✎ The London Eye is 450 feet (135 m) high. Draw the view
afforded the lucky tourist perched in the uppermost capsule.

BIG BEN

Nothing says "merry olde England" like Big Ben.
To clear up a common misconception, Big Ben is
actually the nickname of the famous tolling bells
atop the tower—not the clock or the tower itself.
Standing at the north end of Westminster, the
tower opened in 1859, and Big Ben first struck
in July of that year. It was recently renamed
Elizabeth Tower in honor of Queen Elizabeth II's
Diamond Jubilee.

✎ Climb the 334 steps to the belfry, and complete
this landscape from the view at the top.

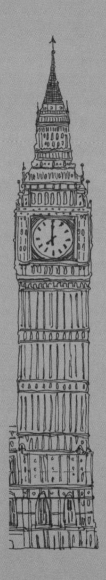

THE SHARD

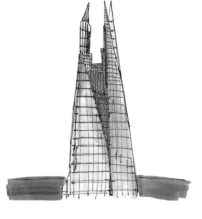

London may have a long, rich history,
but it has always kept its eye on modern
times. It should be no surprise then
that the city's newest and tallest
architectural resident offers a "sharp"
nod to the future. Completed in 2012,
the Shard—an ice-pick-shaped skyscraper—is now the tallest
building in Western Europe at 1,016 feet (309.6 m). Containing
11,000 glass panels and 44 lifts, 95% of the building's materials
are recycled.

✎ Sketch the view of Old London Town from the Shard's
observation deck.

ART

TATE BRITAIN

Tate Britain is the home of the Turner Prize, the prestigious annual award for contemporary art. The prize is named after the great 19th-century landscape painter J. M. W. Turner, and Tate Britain boasts the world's largest collection of the artist's work.

✎ Turner was referred to as the "painter of light." Sketch the medieval castle with the hazy sun above it in *Norham Castle, Sunrise* (c. 1845).

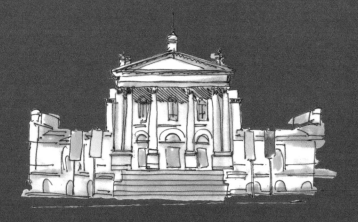

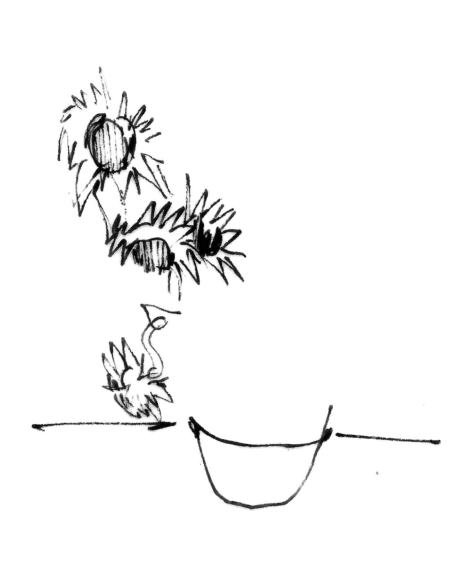

THE NATIONAL GALLERY

Trafalgar Square houses one of the world's largest collections of European art dating from the Middle Ages to the early 20th century in its prestigious National Gallery. Along with masterpieces from Caravaggio, Van Gogh, and Monet, the collection includes a large number of J. M. W. Turner's paintings, bequeathed to the nation in his will.

✐ Vincent Van Gogh's *Sunflowers* (1888)—one of the most famous of the Dutch artist's works—was part of a series of four paintings made to decorate fellow artist Paul Gauguin's bedroom in sunny southern France. Draw the remaining ten (of fourteen) sunflowers in various shades of the artist's favorite color, yellow, in the slightly lop-sided ceramic vase.

TATE MODERN

Britain's national gallery of international modern and contemporary art, the Tate Modern, is based in a former power station on the south side of the Thames. The electricity generators in the gallery's Turbine Hall have been replaced with large, specially commissioned artworks from artists like Louise Bourgeois, Anish Kapoor, Bruce Nauman, and Ai Weiwei.

✎ When Ai Weiwei's exhibition, *Sunflower Seeds*, opened in 2010, visitors were initially able to walk among the 100 million hand-sculpted, painted porcelain sunflower seeds. Draw a view of this installation, looking down on the visitors walking and lying in the piles of black, gray, and white seeds below.

THE WHITECHAPEL GALLERY

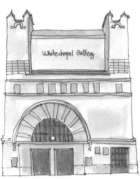

The Whitechapel Gallery has been presenting
art to the people of East London since 1901. Its
first exhibition—of the Pre-Raphaelite painters
William Holman Hunt, John Everett Millais, and
Dante Gabriel Rossetti—attracted over 200,000 local visitors.
The gallery is known for premiering solo shows by artists before
they've become famous, including Picasso, Rothko, and Pollock.

✏️ Sketch the stone entrance arch with its semi-circular window
as well as the gallery sign on this stunning Arts and Crafts building.
Include a family of four on its way in to visit the latest exhibition.

NATIONAL PORTRAIT GALLERY

Founded in 1856 to display portraits of famous Britons throughout history, the National Portrait Gallery has the largest collection of portraiture in the world. Among the 195,000 portraits are paintings of the royal family throughout history, the famous (and still disputed) "Chandos" portrait of William Shakespeare, as well as photographs of rock and fashion royalty like the Rolling Stones and Kate Moss.

✎ Sketch Patrick Branwell Brontë's 1834 painting of his famous novelist sisters by drawing Emily Brontë in her simple green gown between her sisters, Anne and Charlotte. Add the silhouette of the shadowy male figure to her right who has been painted out.

National
Portrait
Gallery

THE FOURTH PLINTH IN TRAFALGAR SQUARE

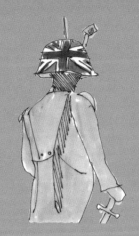

Though intended to hold a statue of King William IV on his horse, insufficient funds for the Fourth Plinth in Trafalgar Square meant that didn't ever happen. Instead, after remaining empty for 150 years, it was decided that rotating works of contemporary art would grace the top. One of the most controversial commissions was Antony Gormley's *One & Other* where 2,400 members of the public each spent one hour on the plinth doing anything they wished!

🖉 Draw a small crowd of tourists gathered at the base of the plinth's 2014 sculpture by Katharina Fritsch of a fifteen-foot-high blue cockerel intended to represent strength, awakening, and regeneration.

SIR JOHN SOANE'S MUSEUM

On beautiful Lincoln's Inn Fields, Sir John Soane's Museum is the former home of the architect of the Bank of England. The museum houses Sir John Soane's vast collection of antiques, furniture, paintings, and artifacts.

✎ One of the gems of the museum is Hogarth's *A Rake's Progress* (1733), a series of eight paintings following the life and ruin of Tom Rakewell. Choose one of the eight paintings and sketch the hero along with some of his companions in their 18th-century finery. Add Tom's small black-and-white dog looking on in amazement at the crazy behavior of the humans around him.

THE WALLACE COLLECTION

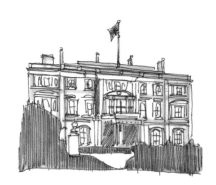

The Wallace Collection, featuring a wonderful collection of 15th-to 19th-century art previously owned by the Wallace family, is displayed in Hertford House, a grand 18th-century townhouse in central London.

✏ Draw the young woman on the swing in Jean-Honoré Fragonard's best-known painting, *The Swing* (1767). Capture the contrast of the girl's frothy pink silk dress to the greenery around her, along with her would-be suitor lounging on the ground below.

THE VICTORIA AND ALBERT MUSEUM

The Victoria and Albert Museum (more commonly called the V&A), named after Queen Victoria and Prince Albert in 1852, holds over 4.5 million objects in seven miles of galleries and is the world's largest museum of decorative arts and design.

✎ The sculpture courts at the V&A are packed with magnificent plaster casts of ancient sculptures including Michelangelo's *David*. After a visit by Queen Victoria, a plaster fig leaf was cast to cover David's nudity on her future visits. Finish sketching the pedestal on which the statue stands, and add the fig leaf hanging on David using two strategically placed hooks.

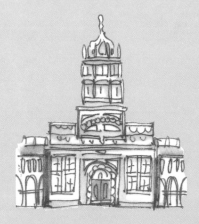

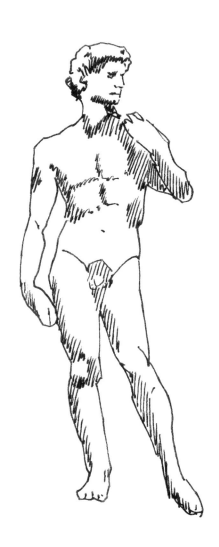

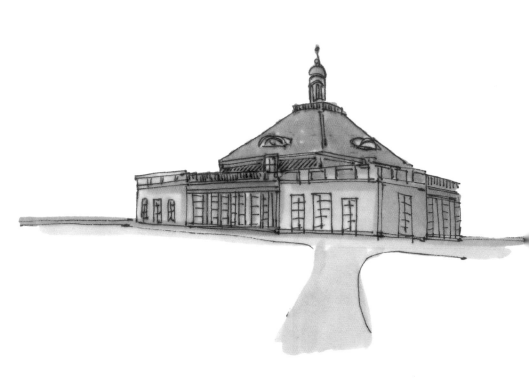

THE SERPENTINE GALLERY

Take a stroll through Hyde Park, one of London's grand parks, to visit the Serpentine Gallery, which is housed in a classical 1934 tea pavilion near the Serpentine Lake. Focusing on modern and contemporary art, the Serpentine has shown internationally recognized artists like Louise Bourgeois, Jeff Koons, and Andy Warhol. Each year from July to October, a temporary pavilion with a café opens to host talks and events. Commissioned architects have included Zaha Hadid, Daniel Libeskind, and Frank Gehry.

✏ Draw two friends playing ping-pong inside French architect Jean Nouvel's geometric red gallery pavilion (2010) on a sunny day in July.

THE SAATCHI GALLERY

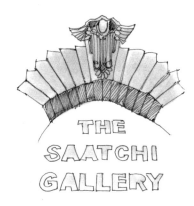

The Saatchi Gallery in Chelsea is a showcase for ex-advertising mogul Charles Saatchi's vast collection of contemporary art. Famous both for establishing the careers of contemporary artists like Damien Hirst and Tracey Emin and for marrying the chef Nigella Lawson, Mr. Saatchi has never been a stranger to controversy. His *Sensation* show was met with much protest when it toured the Brooklyn Museum because of Chris Ofili's *The Holy Virgin Mary* (1996), a painting that included elephant dung on the canvas.

✎ Complete the outside view of the gallery, a former 19th-century military headquarters, by sketching the four grand white pillars at the entrance, the gray vertical banners with the gallery name, and a few visitors on the steps.

THE BARBICAN ART GALLERY

The Brutalist concrete structure housing the Barbican Art Gallery inspires either admiration or dislike, and has often been voted London's ugliest building. Inside, however, visitors are treated to an admirable range of contemporary art, architecture, design, and fashion exhibitions.

✐ The first major retrospective of the late Helen Chadwick's work in 2004 featured *Cacao* (1994), a chocolate fountain, signifying both pleasure and excess. Sketch the circular pool with a group of visitors looking very tempted to dip their fingers into the bubbling melted chocolate.

THE INSTITUTE OF CONTEMPORARY ARTS

Founded in 1946 by a group of artists to show cutting-edge art, the Institute of Contemporary Arts (ICA) has presented important shows by Pablo Picasso and Jackson Pollock as well as debut shows by today's highest-profile artists, including Damien Hirst, the Chapman brothers, and Steve McQueen.

The ICA is located in a beautiful terraced Regency-period building overlooking St. James's Park on The Mall, the wide tree-lined avenue leading up to Buckingham Palace. Finish the ICA's row of creamy pillars, terrace, and the sign over the entrance.

CULTURE

ROWING ON THE THAMES

The River Thames is one of the busiest spots for rowing in England, and the Thames Rowing Club along London's Embankment is one of the oldest and most prestigious clubs. In winter months, teams can be seen majestically pulling their oars during early-morning practice, and when regattas take place, the riverbanks are filled with friends and family cheering the racers on.

✎ Picture a busy regatta and fill in the sketch by adding several teams racing to the finish line. Add London Bridge in the background and a throng of flag-waving well-wishers on the sidelines.

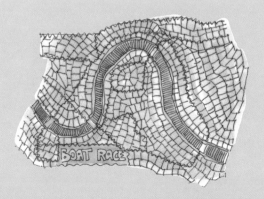

BOAT RACE

ENGLAND

FOOTBALL MATCH

Football—known to Americans as soccer—is a religion, an obsession, and a way of life in England. Every young English lad has a team he supports for life, sticking faithfully by them in good years and bad. Football players are household names, and so are their equally famous WAGs (wives and girlfriends), who support their men—as well as an entire fashion industry!

🖊 Add an outline of a football field and pick your favorite team—or one that sounds good!—as they face their biggest rival. Capture the eclectic energy of the sport by adding a player jumping up dramatically to kick the ball, and add in one of the smartly dressed managers watching with great anticipation from the sidelines.

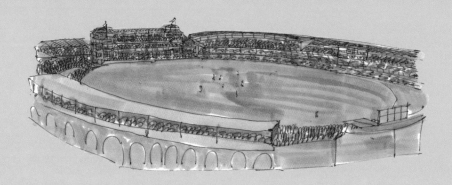

LORD'S CRICKET GROUND

Another beloved English sport—rivaling football as the national sport—is cricket, a bat-and-ball game first played in England in the 16th century. Each team has 11 players, and a match can last up to five days! Lord's is the official home of cricket, and its current site in northwest London has been drawing world-renowned cricketers to the pitch for two hundred years.

✎ Sketch Lord's Cricket Ground, and be sure to add a pristine field and the cricket pitch in the middle. Draw the many bleachers surrounding the field and be sure to incorporate some cricket gear into the sketch, such as a wooden bat, balls, helmets, and batting gloves.

LORD
CRICKET
GROUND

NOTTING HILL CARNIVAL

The annual Caribbean-influenced Notting Hill Carnival has been going strong since 1966. During the last weekend in August, the streets of Notting Hill are jam-packed with locals and tourists dancing in the streets, enjoying spicy dishes from street vendors, and watching performers adorned in feathers and sequins. Music fills the air as musicians and DJs take to the streets as well.

✎ Think huge feathered headpieces, skimpy costumes, and throngs of people dancing in the streets. Add a few Caribbean food stalls alongside the pretty houses on Portobello Road and get ready to party!

ENGLISH NATIONAL OPERA

The English National Opera, or ENO as those in the know refer to it, is one of two opera houses in London's Covent Garden. Whether you are watching *Carmen*, *Madame Butterfly*, or an opera by Britten, every production is sung in English only. The opera company's home is the London Coliseum, a grand old theater with an imposing stage.

✎ Sketch the stage from the perspective of the balcony seats looking down on a live performance. The enormous curtains hang grandly to the sides. Be sure to add the stage's regal archway and the gilded Coliseum crest above it.

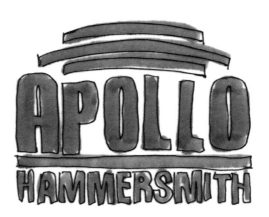

THE HAMMERSMITH APOLLO

The Apollo opened in 1932 and has been one of the top music venues in London ever since. British music giants, including The Beatles, David Bowie, Elton John, Pink Floyd, and Queen have all graced the stage, along with many of their American counterparts, such as Tony Bennett and Bruce Springsteen. Today you might catch the latest indie band or a sold-out performance from your favorite comedian.

✎ Complete the sketch by drawing the Art Deco façade. Include a marquee above the door, listing your favorite band and several other upcoming shows.

THE OLD VIC THEATRE

The Old Vic theater company, established in 1929 and developed by Sir John Gielgud, has a permanent residence at the Old Vic, a charming 19th-century theater near Waterloo Station. Since 2003, artistic director Kevin Spacey has injected some Hollywood glamour—and much-needed fund-raising clout—into one of the most famous theaters in the world. The most celebrated of English actors have all treaded on the boards throughout its colorful history.

✎ Sketch by drawing the outside of the six-columned theater with a lighted billboard announcing the most recent play. You could add the theater's unusual street name, The Cut, to the building as well.

RONNIE SCOTT'S JAZZ CLUB

Ronnie Scott's first opened its doors in 1959, and jazz greats and their legions of fans have been flocking to this Soho institution ever since. With red plush seats and miniature lamps on the tables, the venue combines an atmospheric setting with some of the best jazz performers this side of New Orleans.

✎ Set the scene for a late night of jazz and dinner. Draw several round tables and chairs, table lamps, and place settings complete with wine glasses. Add the famous Ronnie Scott's sign with the venue name, saxophonist, and the words "8:30 P.M. to 3 A.M. open nightly" illuminated brightly.

LONDON CINEMA

Londoners are avid movie buffs and some of the oldest cinemas in London—including the Coronet, which began as a theater in 1898, and the Electric Cinema, which opened in 1910—are in Notting Hill. In the West End, remaining independent cinemas like the Prince Charles have fun, themed events and a stylish bar and cafe to help you make the most of your movie-going experience.

✏ Complete the sketch by adding a charming box office in an old-style theater setting. Add an old-fashioned food counter where you can select a soft drink, glass of wine, some sweets, or next month's program before settling in for an afternoon or evening at the cinema.

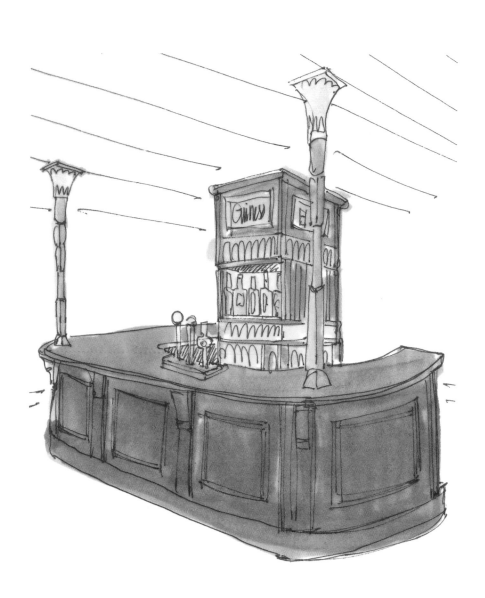

THE PUB

The pub, or public house as it was originally known, remains a second home to the true Londoner. Your pub of choice, known as your "local," is as dear to you as your best friend or your dog—and both usually make their way "down the pub" too. Pubs still close each night at 11 P.M.; a bell goes off at 10:45 to remind everyone to get in their last drink orders.

🖉 Research your favorite local and draw the fixtures of the bar: beer taps, cozy stools, tables, and chairs. Include a fireplace, some old paintings, or a small shelf of books, all with the intention of creating a relaxing home away from home.

HATCHARD'S BOOKS

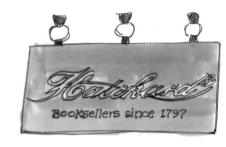

Booksellers since 1797

Founded in 1797 by book lover John Hatchard, this elegant gem in London's Piccadilly is the UK's oldest surviving bookshop. (Mr Hatchard's portrait can be found by one of the shop's regal staircases.) Hatchard's five stories of floor-to-ceiling books provide endless choices for the perfect page-turner. With Buckingham Palace only minutes away, Hatchard's is also the bookseller of choice for the Queen and her royal household.

Doodle one of the beautiful wooden, carpeted spiral staircases along with the rows and rows of books lining the shelves and stacked on tables. Add a few pretty chairs for a reading break.

THE EAST END

For hundreds of years, the East End of London was home to Cockneys with their rhyming slang—"apples and pears" means "stairs," to name one of many examples. Now you're more likely to see a transplanted hipster or trust-fund kid than an original working-class East Ender. Trendy restaurants and bars line the bustling streets, but the occasional "boozer" (dive bar) still hangs on, despite the gentrification.

🖉 Combine the East End of past and present by drawing its narrow streets, brick buildings, and a few old factory signs along with the addition of some trendy restaurants and bars. Don't forget to add in a local newsagent (corner store); they have survived the test of time in every London neighborhood!

GREENWICH

Leafy Greenwich is an area in southeast London steeped in history and culture. Home to the Royal Naval College, the Maritime Museum, the Cutty Sark, the Royal Observatory, and the University of Greenwich, it is also the birthplace of Elizabeth I and Henry VIII. If that isn't enough to keep you busy, have a wander through Greenwich Market or catch a music concert at the famed O2 Arena.

✏️ Finish sketching this scene from the historic Greenwich Market. Fill in the empty stalls with your favorite wares from art and antiques to fashion and jewelry.

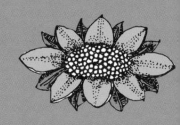

THE ROYAL HORTICULTURAL SOCIETY CHELSEA FLOWER SHOW

Flower Power! Chelsea is one of London's upscale neighborhoods, and for five days each May, it plays host to the Royal Horticultural Society (RHS) Chelsea Flower Show. The extravagant, fragrant flower event is considered the best of its kind in the world—and is certainly the most prestigious. Held on the grounds of the Chelsea Hospital every year since 1913, it is the flower show most closely associated with the royal family, who attend the opening day every year.

✎ Design an award-winning garden that reflects your personal tastes and aesthetic. You can doodle a peaceful zen garden with a small pond or have a wild English garden full of primroses, crocuses, and cowslips.

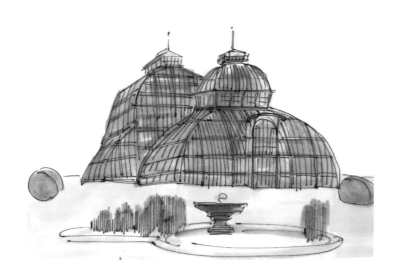

EN POINTE: CLASSICAL BALLET

London hosts two famous classical dance companies: the English National Ballet and the Royal Ballet. Both companies also have world-famous dance schools in London. The Royal Opera House in Covent Garden is home to the Royal Ballet, and during the season, the city is thriving with classical dance where the *barre* is at its highest.

✎ Sketch several young dancers warming up for a ballet class. The room has high ceilings, a shiny barre, and black-and-white images of iconic dancers on the walls. The class is being taught by a former prima ballerina with more than perfect poise.

FOOD

WOODSON'S Fish & Chips

FISH AND CHIPS

Fish and chips is the gin and tonic of food staples to all good Londoners. Traditionally served in wrapped newspaper with a choice of cod or haddock, most fish-and-chip shops today serve their fare on plates or in plastic carryout containers. The venues, however, still offer a sense of the past with blue-checked tablecloths, malted vinegar, salt shakers on each table, and old nautical photographs on the wall.

Stick to tradition and draw a healthy portion of battered fish and thick-cut chips in newspaper. Remember to add a lemon wedge, a serving of tartar sauce, and a sprig of parsley. And don't forget to draw a side dish of mushy peas!

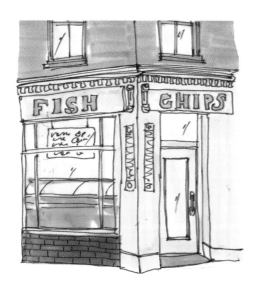

HIGH TEA AT FORTNUM & MASON

There is no better place in London to enjoy the English tradition of afternoon tea—complete with scones and clotted cream—than at the new Diamond Jubilee Tea Salon, located in the world-renowned department store and grocer Fortnum & Mason. You may even find yourself seated next to British royalty. So be sure to book a reservation well in advance!

✐ Draw a beautifully laid table with a crisp linen tablecloth, polished silverware, china plates and teacups, an ornate teapot, and a silver sugar box with tongs. Sketch a three-tier tray with finger sandwiches on top; scones, clotted cream, and preserves in the middle; and a pretty selection of cake slices on the bottom.

FULL ENGLISH BREAKFAST

A "Full English," as it's known, is the Brits' answer to a greasy spoon after a big night out. A heaping plate of bacon, eggs, sausage, home fries, baked beans, fried tomatoes, and mushrooms with a side of white toast will certainly leave you full for the rest of the morning ... not to mention cure that lingering hangover!

✎ Be sure to sketch a big plate in order to fit all the elements of a "Full English," adding your favorite style of eggs, be it scrambled, poached, or fried. As part of the hangover cure, add a large cup of black coffee. Complete the scene with a side of toast with a pat of butter on top.

INDIAN CURRY IN BRICK LANE

Going out for "a curry" is a traditional part of
London life. And the neighborhood of Brick Lane is
an institution, chockablock with Indian and Bangladeshi curry
houses. There are other good options throughout the city, but
an evening in Brick Lane always promises to be as spicy as the
food itself.

✎ Draw a medley of dishes in metal serving trays with side handles.
Add pretty garnishes to each dish: a few sliced almonds or a sprinkling
of cilantro leaves. Complete the sketch with a bowl of rice, some naan
bread, and a big bottle of beer to offset the flavorfully hot dishes.

CHEESEMONGERS PAXTON & WHITFIELD

English cheese has become so highly regarded that even the
French are importing several varieties! Famed cheesemonger
Paxton & Whitfield has been in business since 1797. Their
flagship shop off Piccadilly offers a wide variety of hard and
soft cheeses as well as gift baskets, relishes, pickles, jams, and
much more, all in a charming, cozy setting.

✎ Finish the sketch by doodling large barrels of cheese with name
tags on some of them. Set the scene for a tasting with a plate of small
cubed samples, a jar of chutney, and some savory biscuits.

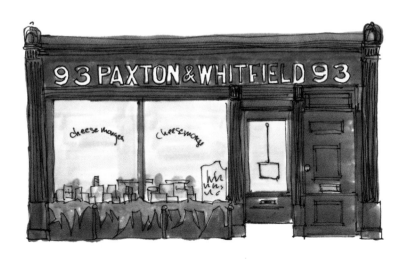

BOROUGH MARKET

Just south of the Thames, Borough Market is one of the largest and oldest food markets in London, selling a large variety of delicacies from all over the world. Alongside the food stalls are wine shops, coffee bars, tapas restaurants, and specialty food shops. It's best to avoid it on Saturday mornings when half of London flocks to this ever-popular covered market.

✐ Complete the sketch by including your own favorite foods available at Borough Market, be it fruit, vegetables, bread, or pastries. Make the items look fresh and delicious, and show them spilling out of baskets or overflowing trays. The market is all about abundance after all!

BILLINGSGATE MARKET

London's first-class fish market is located in a 13-acre building complex on the Isle of Dogs, close to Canary Wharf. In its original location in the 19th century, Billingsgate was the largest fish market in the world, and it remains one of the busiest. Take note that it's the early bird that gets the worm: they start selling at 4 A.M. and finish by 9:30 A.M.

✎ Complete the sketch by drawing a line of crates with an assortment of whole fish on ice, ready to be sold. Add small kippers, large groupers, and prawns in their shells. Draw signs with prices by the kilo and the name of each variety.

HARRODS FOOD HALL

The world-famous Harrods is Europe's biggest department
store and home to an enormous food hall filled with every type
of tasty treat you can imagine from the UK and all over the
world. From Russian caviar and Scotch eggs to Ceylon tea and
Manuka honey, you can spend days drooling over the world's
finest delicacies.

✎ Pick something sweet to draw—fancy cakes or exotic fruit—and
showcase it in a beautiful ornate glass case. Make sure it looks as rich
as you need to be to buy it!

LATE-NIGHT KEBAB

After a night of clubbing,
bar hopping, or pub crawling,
Londoners' choice for satisfying
the munchies is inevitably the
reliable kebab shop, which is open after-hours and is well-stocked
for the late-night crowd. Other menu choices can include burgers
or fish and chips, but the trusty kebab with lots of fixings is
what keeps the tipsy crowds loyal.

✎ Complete the sketch by drawing a busy kebab store front with
quirky signage. Name the shop yourself from Best Ever Kebabs to
Kebab & Pizza. The message is always simple! Illustrate the outline
of a rotating spit in the window and the crowds gathering for their
late-night fix.

SUNDAY ROAST

This English meal is a Sunday pub classic. Picture yourself sitting by a cozy fire, drinking a pint of ale, and reading the Sunday papers while you wait for your roast lamb, beef, or veggie sausages; oven-roasted potatoes; buttered vegetables; and a big round Yorkshire pudding with gravy. The pudding is savory, so save room for a sweet dessert, such as treacle tart or apple crumble.

With a roaring fire in the background, draw a roast dinner with the meat option of your choice and all the trimmings, plus a side of horseradish. Add a pretty gravy boat next to the dish and set them on a rustic wooden table.

PRE-THEATER SUPPER IN COVENT GARDEN

Many restaurants in London's theater district offer a pre-theater set menu for those wanting a quick bite before the show. The celeb-frequented Ivy restaurant is no exception. The doorman greets you with a smile, and the maître d' seats you at one of the cozy tables—just like they did when they first opened their doors in 1917.

✎ The Ivy's menu is all about upscale comfort food. Draw a plate of sausage and mash (mashed potatoes) with a few side dishes, perhaps green beans with shallots and a mesclun salad. As you are in theater mode, add a glass of champagne, *dahling*, next to your ticket stubs announcing the hottest show in town.

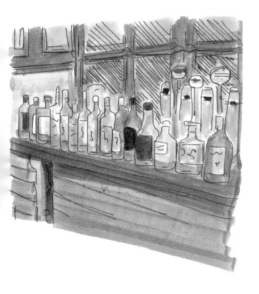

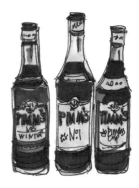

PIMM'S

At the first sign of summer, Londoners will head to the pub to order a jug of Pimm's. A gin-based spirit, Pimm's is incredibly refreshing (and surprisingly potent) when poured into a jug with lemonade, fresh fruit, and sliced cucumber. But as all good things must come to an end, when the summer is over, the Pimm's season is too for yet another year.

✎ Draw a clear jug of Pimm's with the traditional recipe of sliced oranges, strawberries, and cucumber. Fill a few glasses with ice and decorative sprigs of mint. For an added challenge, add a bottle of Pimm's to the sketch, complete with its iconic label.

CHINATOWN

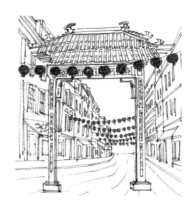

In the 1970s, London's Chinatown moved from the East End of London to popular Soho. The neighborhood now boasts around 80 restaurants featuring some of the city's finest and most authentic Asian cuisine, as well as green grocers selling Chinese fruits, vegetables, and grains. Street signs are bilingual, and during Chinese New Year, the streets are bursting with red lanterns and colorful bunting.

✎ Draw a table with several plates of dim sum in bamboo baskets. Sketch three to four pieces per basket, with one containing a small bowl of dipping sauce. Include chopsticks resting on a stand next to the dishes along with a pot of green tea and two dainty cups.

GASTROPUBS

Now a household word, the term "gastropub" was first coined at London's Eagle pub in the early 1990s. Pub grub in London wasn't exactly known for its quality or variety until the gastropub revolutionized pub food for a nation—and beyond. Foodies now flock to these spots to seek out the best of a wide variety of classic British food with a fresh, modern twist.

✎ Draw a chalkboard with a variety of menu selections. Doodle a starter of smoked trout and dill mousse, along with new potatoes and beetroot salad drizzled with olive oil. Accompany it with a basket of fresh brown bread and a glass of sauvignon blanc. All organic, naturally!

CELEBRITY CHEFS

Celebrity chefs have become a 21st-century phenomenon. The big ones are household names—Gordon, Nigella, Jamie—and each has a unique style. Be it profuse cursing in the kitchen, sensually stirring a chocolate sauce, or being a smiley, cheeky chappy, all of them preside over vast empires of cookbooks, television shows, restaurants, or signature ranges of cookware.

Pick your favorite London-based celebrity chef and sketch a true likeness of him or her turning up the heat! Draw the chef preparing a dish on TV, surrounded by small bowls of ingredients, a mixer or blender, and a chopping board, and show him or her sporting an apron.

PEOPLE-WATCHING

PUTTIN' ON THE RITZ

Everyone from Charlie Chaplin and Sir Winston Churchill to
Judy Garland and Noel Coward has dined at The Ritz. Both the
famed Palm Court and The Ritz Restaurant are incredibly regal,
steeped in history, and guaranteed to make your heart—and
wallet—feel much lighter.

✎ Remembering there is a strict dress code at The Ritz, sketch two
diners on a romantic evening out, sharing a bottle of champagne at
the start of an elegant three-course meal. The headwaiter is in a black
suit and bow tie and the other diners are equally dressed to the nines.

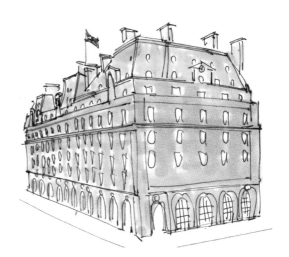

A NIGHT AT THE THEATER

Agatha Christie's whodunit murder mystery *The Mousetrap* has been charming audiences in London's West End theater district since 1952, making it the longest run of any play in history. Its home is the St Martin's Theatre in Covent Garden, and though the actors have of course changed over the years, the sharp dialogue and quirky British characters have stood the test of time.

✎ *The Mousetrap* takes place in fictional Monkswell Manor, recently converted to a guesthouse. Sketch a grand old room with well-worn furniture and throw rugs, wood paneling, high ceilings and windows, and more than an air of mystery to complete the scene.

BLACK CABS

Official London taxis, known as "black cabs," are as ubiquitous as the corner pub. Drivers must go through a rigorous training program referred to as "the Knowledge" before getting licensed, a process that can take up to four years. A London cab driver is typically chatty, articulate, highly opinionated—and king of all city roads.

✎ Complete the sketch by adding some passengers in the black cab that is stuck in traffic. Also include a group of would-be passengers standing under the umbrellas waiting to catch a ride. Doodle interesting patterns on each of their umbrellas to lighten the gray day.

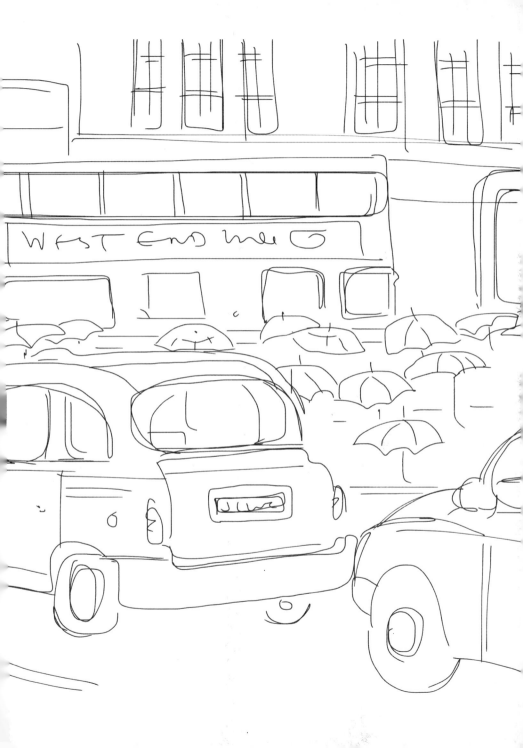

WIMBLEDON TENNIS CHAMPIONSHIPS

For two intense weeks in late June, the grass courts of the All England Lawn Tennis Club in Wimbledon host the oldest tennis tournament in the world. If you're lucky enough to get tickets, you'll be intent on watching the score, both on and off the courts, as celebrities and royalty alike flock to take part in the match of the day.

✏ Draw some well-dressed ladies and smart, casually outfitted men obsessed with every game point, while neighbors on either side gossip away. Finish the sketch with an outline of an intense match at center court.

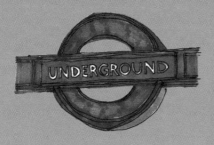

THE LONDON UNDERGROUND

Every year more than a billion passengers use the London Underground, more commonly known as "the Tube." If you happen to be underground between 5–7 P.M., with fellow passengers eager to get home or to the pub, you will be able to put your people-watching skills to good use!

✎ Sketch a variety of people on the Tube. A man and his dog, a kid zoned out on his headphones, friends on their way to a night out, a woman reading the paper. If you can, find room in the sketch for the iconic Underground sign, and always remember to "mind the gap."

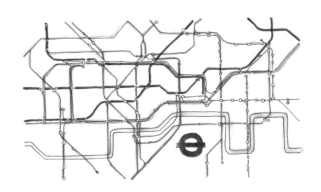

MIND THE GAP

THE CLUB SCENE

London has a huge club scene, be it in gay-friendly Soho, hipster East End, or upscale Mayfair or Kensington. Whatever your preference, you can always find a hopping venue. Even though the pubs close at 11 P.M., you can dance till dawn—and beyond—at your club of choice.

✎ Pick somewhere to see and be "scene," and create a party below by sketching people on the dance floor or queuing up to get past the bouncers. Rule Cool Britannia!

LEICESTER SQUARE FILM PREMIERES

When a big Hollywood film premieres in London, this is where the film stars, paparazzi, and fans go to celebrate the blockbuster opening. Leicester Square has several movie theaters, but these premieres are mainly an excuse for the stars to walk the red carpet and wave theatrically to their legions of fans.

✏ Doodle the arrival of your favorite actor and actress. Think British stars (a famous Harry, perhaps?) in the glare of the spotlight, sharing their gleaming smiles with the cordoned-off fans holding smartphones in the air hoping to capture this special moment on camera.

DOUBLE-DECKER BUS

As someone once astutely observed, the only way to see London is from the top of a double-decker bus. With 24-hour bus routes throughout the city, you can easily travel across Waterloo Bridge, see the dome of St. Paul's, stop along Piccadilly or up Charing Cross Road, and create your own sightseeing trip to London's famous landmarks for much less than any guided tours.

✏ Complete the sketch from the viewpoint of a passenger who is seated in the front row of the top deck. Across the aisle, kids are eagerly looking out too. Let your imagination wander and choose the sights you want to see, either from the list above or another famous route.

OXFORD STREET

Oxford Street runs through central London and is lined with all the big chain stores, so it is considered by many to be a shopper's paradise; with shops like Debenhams, John Lewis, Urban Outfitters, Topshop, and more, it culminates with the world-famous Selfridges department store for the most high-end shopping experience. With the promise of a pedestrian zone one day, shoppers already assert their right-of-way against any cars or buses that dare interrupt their shopping mission.

✎ Complete the sketch opposite with a scene from Oxford Street, right by the Oxford Circus Tube station: Doodle couples browsing and teenage girls buying. Make this a festive pre-Christmas weekend with decorations and colorful lights hanging above.

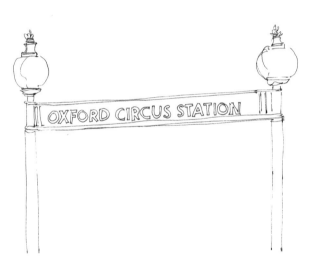

OUTDOOR PUBS

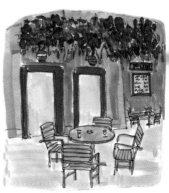

For many the pub is a second home where
you can unwind and meet your mates,
have a quick drink on the way home, or
relax in a pub garden nursing a pint or three. In summertime—
day or evening—an outdoor pub is filled with people enjoying
themselves and waxing philosophical on anything from The
Coronation of Queen Elizabeth II to *Coronation Street*.

Sketch below by drawing a pretty garden pub surrounded by
flowers, hanging plants, and patio umbrellas. The space can be at the
front of the building so you can see the pub sign and the front entrance.
The picnic tables are filled with people and plenty of pint glasses on
the tabletops. Don't forget to add a lounging dog nearby!

ABBEY ROAD CROSSWALK

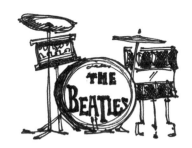

Possibly the most famous photo in British music history is the shot of the four lads from Liverpool walking across the crosswalk near their one-time studio, Abbey Road. To this day, thousands of Beatles fans continue to flock to the destination in northwest London to recreate the unforgettable album cover.

✎ Imagine you and your three BFFs strutting across the crosswalk in single file. Have fun with your clothing (and footwear) choices and hairstyles, or stay true to the 1969 original.

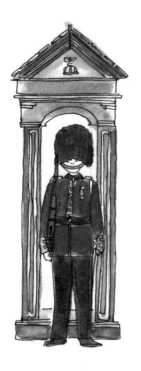

CHANGING OF THE GUARD AT BUCKINGHAM PALACE

The Queen's Guards, in their iconic bearskin caps and scarlet jackets, protect the Queen and her castle around the clock. When one regiment takes over the shift of another, they perform a mesmerizing, centuries-old changing-of-the-guard ceremony.

✐ Complete the sketch by drawing the guards and their famous uniforms, with the gates of Buckingham Palace in the foreground. Their shiny weapons rest on their shoulders, and their arms and feet swing in unison.

A DAY AT THE RACES: EN ROUTE TO ASCOT

Situated only six miles from Windsor Castle, Ascot Racecourse is very closely associated with the royal family. There the royals are joined by many other thoroughbred horse-racing enthusiasts. Unlike the Queen, however, many people travel to Ascot by train from Waterloo Station to attend the summer racing season, decked out in all their finery.

✎ Sketch a scene at Ascot and remember that there is a dress code: for women, hemlines at or below the knee, and for gentlemen, a suit and tie. Women wear the most elaborate hats, so go to town showing as crazy and imaginative a headpiece as you can, and draw the men in top hats!

ENCLOSURE
ANDSTAND ENCLOSURE

ROYAL ASCOT

GRAND STAND ENCLOSURE
SILVER RING

CAMDEN

The goth life may be long gone for many, but in Camden the new black will always be well, black. Green or purple hair, piercings anywhere and everywhere outnumbered only by tattoos are de rigueur in this hood. It doesn't get more wild than Camden for good people-watching, so make a night of it and take in the local music scene.

✎ Forget the Union Jack and let the skull and crossbones be the only flag flying proud! Doodle the most outrageous punks and goths you can imagine, as they hang out near a market stall. Chains, capes, sky-high boots, spiked hair, and attitude complete the sketch.

LANDSCAPE

HAMPSTEAD HEATH

The swimming ponds on Hampstead Heath, the large, ancient park in northwest London, have long had a loyal following since opening over a century ago. Some visitors to the Ladies' Pond (yes, no men allowed!) swim every morning all year round.

✎ Draw a woman in a red bathing suit diving into the Ladies' Pond at Hampstead Heath. The tall oak trees surrounding the small circular pond create a peaceful haven for its female visitors. Add a duck and three ducklings swimming past bulrushes and lily pads.

PRIMROSE HILL

At a height of 256 feet (78 m), the summit of Primrose Hill provides a spectacular view of London landmarks, like the Gherkin, the Shard, and the London Eye. The area is also known for its celebrity residents and has been home to actors, writers, and musicians such as Sylvia Plath, Kingsley Amis, Jamie Oliver, Daniel Craig, Kate Hudson, and Gwen Stefani.

✐ As a favorite spot to ring in the New Year, Primrose Hill is filled with thousands of families each December 31. Draw the crowds enjoying the fireworks and the Chinese lanterns lighting up the skies.

REGENT'S PARK

One of London's Royal Parks, Regent's Park was once part of King Henry VIII's hunting grounds. Today, the vast park has a boating pond, an open-air theater, a zoo, and Queen Mary's Gardens, boasting over 12,000 roses in 85 varieties.

✎ Sketch the white roses covering the bower in Queen Mary's Gardens, and add in a wooden bench underneath.

GARDEN

THE CHELSEA PHYSIC GARDEN

A beautiful walled garden, the Chelsea Physic Garden was founded in 1673 by a society of apothecaries to study plants as medicine. Today the garden holds over 5,000 types of plants, many of which are edible or have medicinal properties, including Woolly Foxglove, which contains a substance used to strengthen the heart, and Meadowsweet, from which aspirin was first made.

Draw the Garden of World Medicine, including the path beside it, the wooden sign, and a few of the plants.

KEW GARDENS

Kew Gardens are rightly described as the world's most famous gardens. Created over 250 years ago, the Royal Botanic Gardens at Kew contain the largest collection of living plants in the world, from the massive ten-foot-high Titan Arum to the world's smallest waterlily.

The wrought iron and glass Palm House was built in Victorian times to accommodate the exotic plants being collected by plant hunters from all over the world. Draw a view from inside the Palm House showing the towering double coconut palm tree, whose seeds are known as the world's largest, weighing in at up to 50 pounds.

RICHMOND PARK

Covering 2,500 acres, Richmond Park in the southwest of the city is the largest Royal Park in London, and is famous for the hundreds of deer that have roamed its grounds freely for centuries. Within the park, the Georgian mansion Pembroke Lodge was former home to the Countess of Pembroke and, more recently, to the philosopher Bertrand Russell. Today it provides a welcome tea break for thirsty park visitors.

✎ Over six hundred Red and Fallow deer have made the park their home since 1529. Draw two stags sunning themselves on the grass with the woods in the background.

THE THAMES BARRIER

The Thames Barrier, spanning 1,700 feet (518 m) across the River Thames, is second only in size to a flood barrier in the Netherlands. The barrier, with its ten massive steel gates, prevents London from being flooded by high tides and storms moving in along the river from the North Sea.

🖉 Draw a motorboat with two passengers about to pass through one of the ten steel floodgates of the Thames Barrier.

OLYMPIC PARK

The Queen Elizabeth Olympic Park in Stratford, east London, was the main hub for the 2012 Olympic Games. Post Olympics, tourists continue to flood to the park for tours of the impressive 50,000-plus-seat stadium and the award-winning Velodrome. Olympic Park is also home to Britain's tallest work of public art, a 376-foot (114 m) purple, twisted metal structure by the artist Anish Kapoor.

✎ Draw an aerial view of the Olympic Stadium with its green playing field, and include some of the rows of seats.

PICCADILLY CIRCUS

Piccadilly Circus—*circus* taken from the Latin word for "circle"—is one of the most famous landmarks in central London. Big brand neon signs from Sanyo to Coca-Cola® illuminate one corner, and the theater district is just a stone's throw away along with the iconic Simpsons building on nearby Piccadilly which houses the elegant Waterstones flagship bookstore. The majestic Shaftesbury Monument Memorial Fountain, erected in 1892–1893, is topped by Alfred Gilbert's winged nude statue known as Eros. Tourists and locals alike flock to *Eros* to liaise with friends or as a romantic meeting point to see where the evening takes them.

✎ Draw the famous Circus with its neon signs and with the *Eros* statue at the south end of the square. You can add the entrance of the Piccadilly Circus tube station and a double decker bus bypassing the square. Add the outline of the crowds and a few love birds under the imposing Fountain.

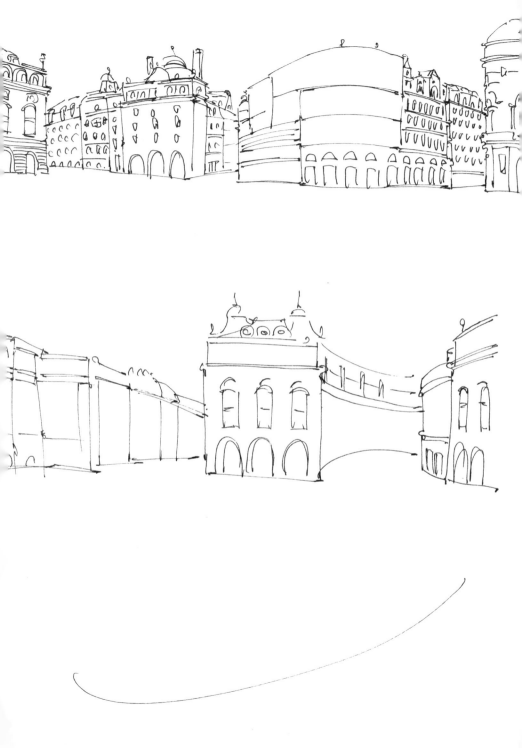

THE SOUTH BANK

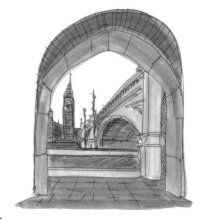

The South Bank of the River Thames
is a popular destination all year round.
It's packed with restaurants and cafés, and is home to the
British Film Institute, the Queen Elizabeth Hall, Hayward Gallery,
and the National Theatre. It's also home to a colorful skate park
loaded with aspiring teenaged skateboarders practicing their
moves around the graffiti-covered walls.

✎ Sketch a young skateboarder soaring off a ramp in the South
Bank's skate park. Onlookers are admiring his grace with the board.
Don't forget to include the graffiti-covered walls behind him.

FASHION

BOND STREET

High-end boutiques on Bond Street include international brands like Armani, DKNY, and Hugo Boss, as well as classic British shops like Asprey, Smythson, and Burberry. Bond Street has been the playground of the wealthy since the eighteenth century, as well as the home of Admiral Horatio Nelson and his mistress, Lady Emma Hamilton.

✎ Draw a view of some of the signs and storefronts on Bond Street. Include a black cab dropping off a well-dressed mother and daughter ready to shop.

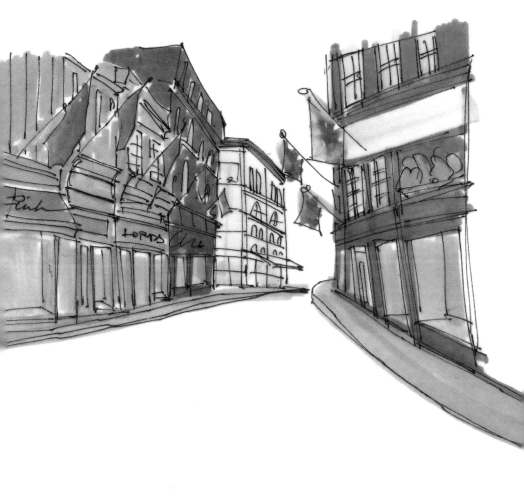

TOPSHOP

Women of all ages flock to the Oxford Circus
flagship branch of Topshop, the largest single
fashion store in the world. Known for setting
trends at affordable prices, this popular chain has collaborated
with model Kate Moss, whose debut collection in 2007 included
a floral-print mini tea-dress that sold out on the first day. The
store, in fact, sells 40,000 of its classic vests each week along
with 30 pairs of panties a *minute.* That's a lot of undies!

✎ Sketch a group of colorfully dressed teenage girls admiring a
window display of the latest Kate Moss collection. Be sure to include
the recognizable Topshop sign above.

LIBERTY

Oscar Wilde once described the Liberty department store as "the chosen resort of the artistic shopper," and it's not difficult to see why. Housed in an elaborate multi-story mock-Tudor building, Liberty is a treasure trove of art objects from around the world, high fashion, and, of course, those famous Liberty print fabrics.

✏ Finish drawing the red berries in the classic leaf and berry pattern of this 1933 Wiltshire print from Liberty.

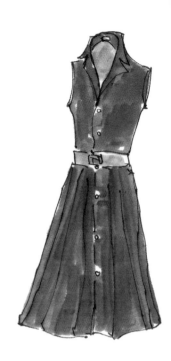

LONDON FASHION WEEK

The semi-annual London Fashion Week, hosted by the British Fashion Council, is one of the world's major fashion events. Writers, buyers, and celebrities vie for front-row seats to see the gorgeous models strut down the catwalk in next season's designs. London Fashion Week has launched the careers of some of the world's top designers like Stella McCartney, whose entire collection sold out after her first catwalk show.

✎ Sketch a group of fashionistas, all dressed in black and squashed onto the narrow front-row bench, as they watch a brightly dressed model try not to tumble off her sky-high heels. Include photographers at the bottom of the catwalk all trying to get a great shot to send to their editors.

VIVIENNE WESTWOOD

British fashion designer Vivienne Westwood became well known in the 1970s for popularizing punk fashion at SEX, a Chelsea clothing shop she ran with Sex Pistols' manager Malcolm McLaren. Today her punk-inspired clothing and jewelry continue to have an eager following. Actresses Helena Bonham Carter and Christina Hendricks are often seen at red-carpet events in Westwood frocks. Carrie Bradshaw notably wore a Vivienne Westwood gown to her wedding in the *Sex and the City* movie, and in real life, a shortened version of the same dress sold out online in just a few hours.

✎ Sketch one of Vivienne Westwood's trademark silk taffeta dresses with its sharp lines, angles, and uneven hemline.

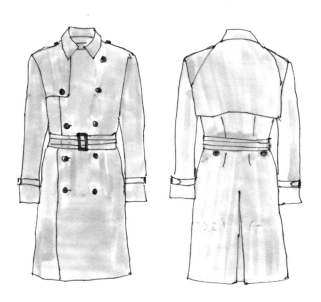

BURBERRY & AQUASCUTUM

Chicken or the egg? Burberry and Aquascutum both claim to have invented the trench coat for the British army. Although remarkably similar, the Burberry trench is shorter and appeals to a trendier customer. Regardless of who was first, these two famous British brands continue to sell the classic coat in vast quantities around the world.

✏ Draw an elegant young woman wearing a classic beige trench coat and dashing through the rain. Be sure to show the checked lining and belt of the coat and include a matching umbrella, always a necessity in London.

MARY'S LIVING & GIVING

Mary's Living & Giving is a great example of a popular British institution: a charity shop where second-hand clothing, household items, and books can be bought for next to nothing. You can often score great deals on designer clothes and vintage finds, and what's more, all the profits go to charities like Oxfam or Save the Children.

✎ Draw the window display of Mary's Living & Giving in Primrose Hill. Include a couple of mannequins, one dressed in a green silk wrap dress, a pair of black stilettos, and a matching black purse, the other in an outfit of your choice.

BURLINGTON ARCADE

Burlington Arcade is a lovely example of a 19th-century shopping center, the first enclosed shopping street in London. The street was originally covered to close off an alleyway behind Burlington House—Lord George Cavendish's mansion—because it was basically a dumping ground for bottles, oyster shells, and dead animals. A far cry from its seedy roots, today's Burlington Arcade features fine jewelry and other fashionable items in a parade of luxurious shops like Harrys of London, the House of Cashmere, Lulu Guiness, and more.

🖉 Draw one of the guards of the arcade, a Burlington Beadle, in his traditional uniform of top hat and double-breasted frock coat as he stands under the grand entrance arches of the arcade attempting to keep out the "riffraff."

FASHION AND TEXTILE MUSEUM

The Fashion and Textile Museum in Bermondsey, South London, shows a changing program of textile and jewelry exhibitions that focus on fashion from 1947 to the present day. The museum is housed over two floors and features exhibitions like the "Little Black Dress" which charted the history of that essential piece, a key part of every woman's wardrobe. Iconic British fashion designer Zandra Rhodes, easily identified by her pink hair and theatrical makeup, founded the museum.

✎ Sketch some outfits from the museum's permanent collection from designers like Christian Dior, Balenciaga, Biba, and Mary Quant.

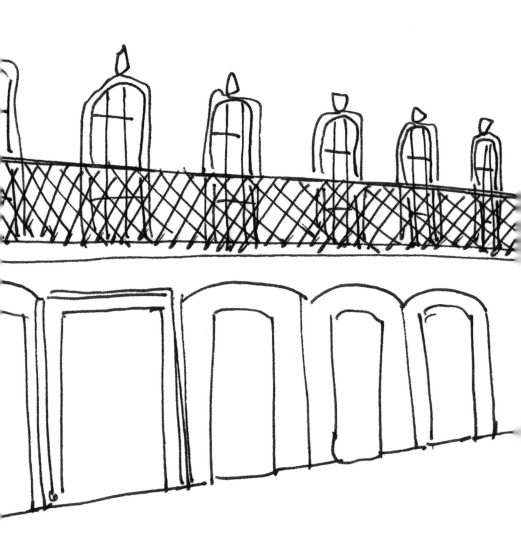

PAUL SMITH

Multi-colored stripes are the signature of one of Britain's best-known menswear designers, Paul Smith. What started off in the early 1970s as a quintessentially British label has become one of the world's leading fashion brands. Sir Paul Smith was awarded a knighthood in 2000, a distinction that until then had only been awarded to one other fashion designer: Sir Hardy Amies.

✎ Draw a window display outside of a Paul Smith shop including a shirt, scarf, cufflinks, and socks, all in his iconic slim multi-colored stripes.

MULBERRY

A girl can never have too many shoes or bags, and if budget weren't an issue, a Mulberry bag would be in every woman's collection. These popular leather bags come in a wide variety of colors and have an instantly recognizable boxy shape and signature short handles. The brand was named after a mulberry tree that the founder strolled past in his native Somerset which is why the tree logo appears discreetly on each and every bag.

✎ Mulberry bags are known by their shape and name: the Lily, the Alexa, and the Bayswater. Draw a bag of your choice on the arm of an English fashionista.

BOXPARK SHOREDITCH

Described as the world's first pop-up mall, Boxpark was constructed out of shipping containers and reflects the creative area that is Shoreditch. Filled with clothing and shoe shops aimed at hipsters who live and work in the area, this temporary shopping mall is only meant to be there for a few years, so visit now!

✎ Sketch a Shoreditch hipster (bearded, of course) coming out of the Puma store loaded down with bags.

CARNABY STREET

Carnaby Street was the center of "Swinging London" in the 1960s, and everybody who considered themselves hip shopped the boutiques there, including the Rolling Stones, The Beatles, and The Kinks. (Austin Powers' fans may well remember that his 1969 apartment was on Carnaby Street.) Today, the pedestrian street is home to several fashion and apparel retailers, including the Dr. Martens flagship store.

✎ Recreate a scene from the swinging '60s including a group of stylish Mods in suits trying to attract the attention of some mini-skirted girls.

CARNABY STREET W1
CITY OF WESTMINSTER

SAVILE ROW

Savile Row has been the go-to street for bespoke men's tailoring since the 19th century, when the dandy Beau Brummell revolutionized the way men dress by introducing the tailored jacket and slim trousers. Gieves & Hawkes, Hardy Amies, and Ozwald Boateng are just three of the street's well-known tailors, and modern-day dandies, like David Beckham and P Diddy, can occasionally be spotted on this elegant stretch.

Ozwald Boateng received his first suit from his mother at age eight, and has said that "style is an extension of yourself." By using bright colors, he puts a twist on classic British tailoring. (You'd be hard-pressed to find a gray pinstriped suit in his store!) Sketch a customer admiring himself in the mirror in one of Boateng's colorful suits.

SELFRIDGES & CO.

Selfridges & Co., the UK's second-largest department store (after Harrods), was founded by Chicago native Harry Gordon Selfridge in 1909. Selfridge aimed to make shopping fun instead of a chore by displaying merchandise where customers could actually handle it themselves instead of having to ask permission to see everything. His revolutionary idea worked, and today the store boasts the largest shoe department in the world, stocking 100,000 pairs of shoes and selling 7,000 pairs a week.

✎ Selfridges is renowned for its imaginative displays both in the store and in its windows. Imagine one of the early windows with two Edwardian ladies in a garden scene wearing long dresses and broad hats with feathers or bows. Include the engraved Selfridge & Co. sign beside the window.

ABOUT THE AUTHORS

MELISSA WOOD is both an illustrator and writer. Her permanent case of wanderlust, coupled with her addiction to history and lifelong love of travel is how the *Citysketch* series was born. She lives and works in the country, a stone's throw from the energy of Chicago. She has three witty children, two poorly behaved dogs, and one fluffy cat.

MONICA MEEHAN is a freelance writer and author of *The Viennese Kitchen: Tante Hertha's Book of Family Recipes.* She also works in publishing and divides her time between New York and London. Monica is an avid traveler, cook, and people-watcher.

JOANNE SHURVELL is an award-winning travel and arts writer. She is also the owner of PayneShurvell, a contemporary art gallery in London.